BIOGRAPHIC
PICASSO

BIOGRAPHIC
PICASSO

NATALIA PRICE-CABRERA

ILLUSTRATED BY
MATT CARR

AMMONITE
PRESS

First published 2019 by
Ammonite Press
an imprint of Guild of Master Craftsman Publications Ltd
Castle Place, 166 High Street, Lewes, East Sussex, BN7 1XU,
United Kingdom
www.ammonitepress.com

ISBN 978 1 78145 337 7

Publisher: Jason Hook
Concept Design: Matt Carr
Design & Illustration: Matt Carr & Robin Shields
Editor: Jamie Pumfrey

Colour reproduction by GMC Reprographics
Printed and bound in Turkey

Picture Credits:
All artworks © Succession Picasso/DACS, London 2019.
p22: AKG Images/Album/Kocinsky; p25: Bridgeman Images/Cleveland
Museum of Art, OH, USA/Gift of the Hanna Fund; p29: Shutterstock/
Carlos Yudica; p49: Bridgeman Images/Private Collection; p57: Digital
image, The Museum of Modern Art, New York/Scala, Florence; p62:
Bridgeman Images/Museo Nacional Centro de Arte Reina Sofia, Madrid,
Spain; p69: © Tate, London 2019; p71: Bridgeman Images/Musee Picasso,
Paris, France/Photo © Photo Josse; p72: Bridgeman Images/Museo
Picasso, Barcelona, Spain; p73: Bridgeman Images/Prado, Madrid, Spain;
p79: Bridgeman Images/Musee d'Art Moderne de la Ville de Paris, Paris,
France; p90: Bridgeman Images/Private Collection.

CONTENTS

ICONOGRAPHIC

WHEN WE CAN RECOGNIZE AN ARTIST BY A SET OF ICONS, WE CAN ALSO RECOGNIZE HOW COMPLETELY THAT ARTIST AND THEIR WORK HAVE ENTERED OUR CULTURE AND OUR CONSCIOUSNESS.

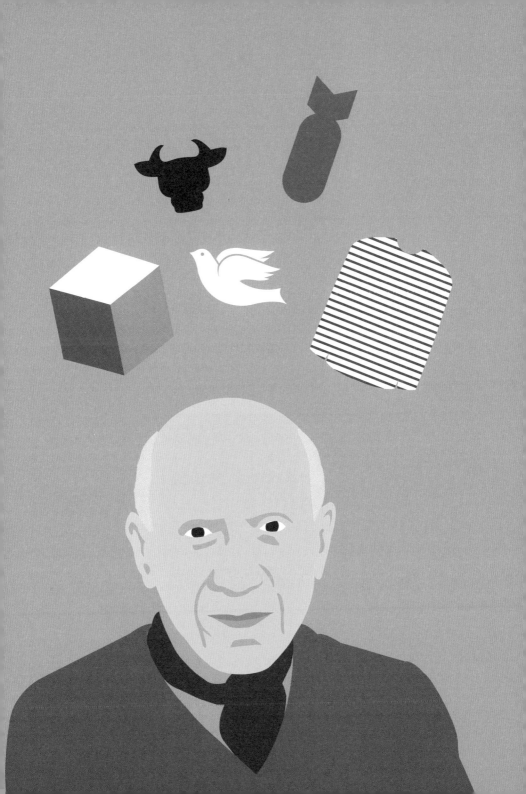

INTRODUCTION

Pablo Picasso was simply the most influential artist of his age. His work was so revolutionary, so pervasive, that it is impossible to imagine the first 70 years of the twentieth century without his metamorphosing presence. Picasso weaves a brilliant thread through the seismic shifts and movements that transformed and questioned the very idea of art. His artistic experimentation was ceaseless, and he reinvented the art world not once but again and again.

Born in 1881, Picasso displayed obvious artistic prowess from a very early age. At the age of seven, he began receiving formal artistic instruction from his father. By the time he was 13, the pupil's ability already far surpassed the teacher's. These were exciting times for a young artist to be discovering his talent. Picasso's immediate predecessors included Paul Gauguin, Vincent van Gogh and Paul Cézanne (who Picasso considered his artistic father). Part of his genius lay in his ability to synthesize such influences and turn any style into something distinctly his own.

"THERE ARE PAINTERS WHO TRANSFORM THE SUN INTO A YELLOW SPOT BUT THERE ARE OTHERS WHO WITH THE HELP OF THEIR ART AND THEIR INTELLIGENCE TRANSFORM A YELLOW SPOT INTO A SUN."

—Pablo Picasso, quoted in *The Film Sense* by Sergei Eisenstein, 1957

In the first decade of the new century, a physicist in his twenties named Albert Einstein presented a theory of relativity that would completely change the way in which the world was understood. At the same time, and only two years younger, Picasso was painting *Les Demoiselles D'Avignon* (see page 56): a masterpiece that would completely change the way in which that world was depicted. The parallel lives of these most revolutionary of contemporaries would play a huge part in defining what we think of as the modern age.

Picasso plotted a dizzying path through Classicism; Realism and Naturalism; the melancholic Blue Period; the more optimistic Rose Period; African art; the co-founding of the Cubist movement; the invention of constructed sculpture; the co-invention of collage; the embrace of Neoclassicism, and experiments in Surrealism. His later pieces revisited the works of great masters, as well as presenting comical and fantastical interpretations of everyday subjects. In his obituary in the *New York Times*, he is rightly described as, 'A one-man history of modern art.'

The *Biographics* series works by converting numbers into infographics, and this seems an appropriate way to try to grapple with Picasso's life and work. He was, after all, one of the most prolific of artists – working in series, image after image, each one metamorphosing into the next. In 1969, at the age of 88, Picasso still had the energy to produce 165 paintings and 45 drawings for an exhibition in Avignon, France, working on several canvases at the same time. In his lifetime, he produced over 150,000 works of art, including more than 13,500 paintings (see page 82).

It is also illuminating to explore the iconography of Picasso's life and work. He was the epitome of the modern artist, charismatic and obsessive, provocative and mischievous, driven by an overwhelming passion for his art. He became the world's wealthiest artist and also its most famous, appearing on the cover of *Time* magazine, as he acquired that other defining mark of the twentieth century: celebrity.

Picasso stated his form as 'traditional painting violated'. Like Einstein, he constantly broke boundaries and challenged the established view. Some works, such as *Les Demoiselles D'Avignon*, were so revolutionary that they caused genuine shock among his peers. Others, such as the anti-war painting *Guernica* (page 62), reflected Picasso's political and humanitarian impact. Whatever he turned his hand to, his vision was so clear, so powerful, that whatever he produced was always 'a Picasso'.

"NO THEORETICIAN, NO WRITER ON ART, HOWEVER INTERESTING HE OR SHE MIGHT BE, COULD BE AS INTERESTING AS PICASSO. A GOOD WRITER ON ART MAY GIVE YOU AN INSIGHT TO PICASSO, BUT, AFTER ALL, PICASSO WAS THERE FIRST."

—David Hockney, quoted in *Hockney on Photography* by Paul Joyce, 1988

PABLO PICASSO

01
LIFE

"MY MOTHER SAID TO ME, 'IF YOU ARE A SOLDIER, YOU WILL BECOME A GENERAL. IF YOU ARE A MONK, YOU WILL BECOME THE POPE.' INSTEAD, I WAS A PAINTER, AND BECAME PICASSO."

—Pablo Picasso, quoted in *Life with Picasso* by Françoise Gilot, 1964

PABLO DIEGO JOSÉ FRANCISCO DE PAULA JUAN NEPOMUCENO CRISPÍN CRISPINIANO MARÍA DE LOS REMEDIOS DE LA SANTÍSIMA TRINIDAD RUIZ PICASSO

was born 25 October 1881 in Málaga, Spain

◀ Also from Málaga: **Jorge Rando** (1941–), painter and sculptor. The Museum Jorge Rando opened in Málaga in 2015.

S P A I N

A N D A L U C I A

Pablo Picasso was born at 11.15pm on the night of 25 October 1881, the first child of José Ruiz y Blasco, a painter and professor of art, and María Picasso y López. He was considered still-born by the midwife until the child's uncle Don Salvador (a renowned doctor), Don Salvador, blew cigar smoke into the baby's nostrils – reviving Pablo instantly. María would go on to have two more children, Lola (born 28 December 1884) and Concepción (born 30 October 1887).

19 FEBRUARY

Kansas becomes the first state in the USA to prohibit all alcoholic beverages.

22 JANUARY

Cleopatra's Needle is erected in Central Park, New York, USA.

4 DECEMBER

The first edition of the *Los Angeles Times* is published.

2 JULY

The US President James A. Garfield is shot by Charles J. Guiteau; Garfield dies 79 days later, on 19 September.

18 APRIL

Billy the Kid escapes from the Lincoln County jail in Mesilla, New Mexico, USA.

THE WORLD IN
1881

4 AUGUST

Temperatures of 122°F (50°C) are reported in Seville, Spain.

18 APRIL

The Natural History Museum opens in South Kensington, London, England.

19 NOVEMBER

A meteorite lands near the village of Grosliebenthal, southwest of Odessa, Ukraine.

16 MAY

The world's first electric tram goes into service in Lichterfelder, near Berlin, Germany.

23 MARCH

The Boers and British sign a peace accord, ending the First Boer War.

PICASSO'S FAMILY TREE

FATHER

José Ruiz y Blasco
(1838–1913)

WIFE

Jacqueline Roque
(1927–86)

WIFE

Olga Khokhlova
(1891–1955)

LOVER

Marie-Thérèse
Walter
(1909–77)

LOVER

Françoise Gilot
(1921–)

DAUGHTER

María de
la Concepción
(Maya) Picasso
(1935–)

DAUGHTER

Anne Paloma
Picasso
(1949–)

SON

Claude Pierre
Pablo Picasso
(1947–)

Picasso's family tree reveals he had several wives and lovers, three of whom bore him children over the course of their lives. The artist's second wife, Jacqueline Roque, was with him up until his sudden death in 1973.

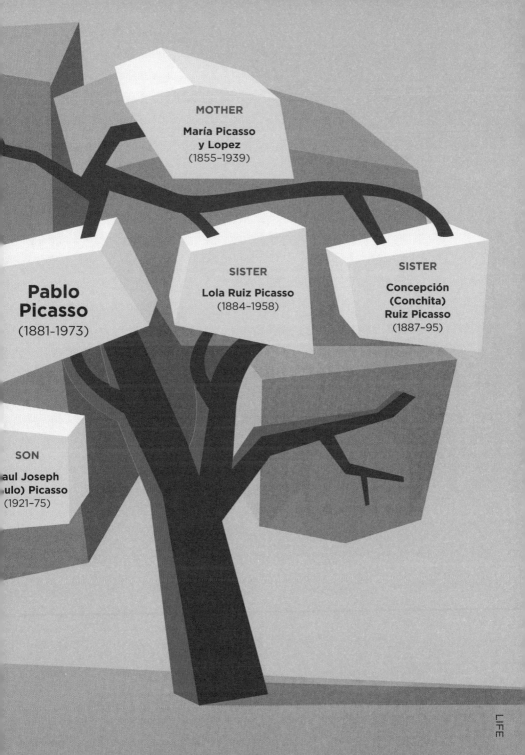

MOTHER

**María Picasso
y Lopez**
(1855–1939)

**Pablo
Picasso**
(1881-1973)

SISTER

Lola Ruiz Picasso
(1884–1958)

SISTER

**Concepción
(Conchita)
Ruiz Picasso**
(1887–95)

SON

**aul Joseph
ulo) Picasso**
(1921–75)

WHAT'S IN A NAME?

In some cultures it is quite common for children to be named after the given or surname of their relatives. In Spain (and other Hispanic countries) children are often also named after saints – more often than not, the patron saint of their birthday.

Following tradition, Picasso was baptized with 10 different names, each one in honour of a different saint or relative. In total, he had 20 words in his name, but by 1901, he was known by just one: Picasso.

PABLO
uncle (Canon Pablo)

DIEGO
grandfather (Diego Ruiz y Almoguera)

JOSÉ
father (José Ruiz y Blasco)

FRANCISCO DE PAULA
grandfather (Francisco de Paula Picasso Guardeño)

JUAN NEPOMUCENO
godfather (Juan Nepomuceno Blasco Barroso)

CRISPÍN CRISPINIANO
two shoemaker saints whose feast day is on Piccaso's birthday

MARÍA DE LOS REMEDIOS
godmother (María de los Remedios Alarcón Herrera)

DE LA SANTÍSIMA TRINIDAD
meaning "of the Holy Trinity"

RUIZ
father (José Ruiz y Blasco)

PICASSO
mother (María Picasso y López)

NOTABLE PEOPLE WITH LONG NAMES:

WOLFGANG AMADEUS MOZART (1756–91)

Full name: Johannes Chrysostomus Wolfgangus Theophilus Mozart

Profession: Pianist, Musician and Composer

Mozart was multilingual and adapted his name to suit different languages. He was baptized on 28 January 1756 as Johannes Chrysostomus Wolfgangus Theophilus Mozart, with his first two names in honour of Catholic saints. Wolfgangus was taken from his maternal grandfather and shortened to Wolfgang in German. Theophilus, after his godfather, was the Greek for 'loved by God' which translated to 'Gottlieb' in German and 'Amadeus' in Latin. His surname was from his father.

DIEGO RIVERA (1886–1957)

Full name: Diego María de la Concepción Juan Nepomuceno Estanislao de la Rivera y Barrientos Acosta y Rodríguez

Profession: Painter

Diego Rivera is still widely regarded as one of the greatest Mexican painters of all time. Together with his wife, Frida Kahlo, the two have left a lasting legacy on the art world. Rivera was born at the end of the 19th century into a Catholic family and his name reflected his religious heritage. He was also baptized with the names of his mother, María del Pilar Barrientos, and father, Diego de la Rivera y Acosta.

RUDOLPH VALENTINO (1895–1926)

Full name: Rodolfo Alfonso Raffaello Pierre Filibert Guglielmi di Valentina d'Antonguolla

Profession: Actor, Dancer, Teacher

Rudolph Valentino was an Italian actor who immigrated to the USA in 1913. Born Rodolfo Alfonso Raffaello Pierre Filibert Guglielmi, he later added di Valentina d'Antonguolla after a relative. In 1918, Valentino moved to Los Angeles to focus on acting, eventually going by the stage name of Rudolph Valentino. He died tragically young at the age of 31.

EARLY YEARS

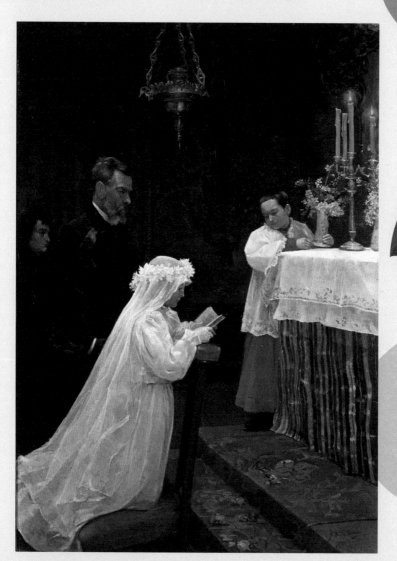

1881

Picasso is born on 25 October.

1896

Picasso completes his first major painting – *La Premiére Communion.*

▲ *La Premiére Communion*
Pablo Picasso
Oil on canvas, 1896
65 x 46 ½ inches
(166 x 118 cm)

1884

On 28 December, Lola Ruiz Picasso, Picasso's sister, is born during an earthquake in Málaga.

1887

Picasso's youngest sister, Concepción (Conchita), is born on 30 October.

1888

Picasso's father starts to give the young artist a formal education in art.

1895

Picasso has his first show in the back room of a shop that sells drapery, umbrellas and knick-knacks. The family moves to Barcelona and Picasso attends La Lonja, Barcelona's school of fine arts.

1895

In January, Picasso's eight-year-old sister Conchita dies of diphtheria. Picasso loses faith in religion and his father vows to give up painting.

1891

The Picasso family moves to La Coruña, where the artist starts to attend his father's ornamental drawing classes.

1897

Aged 16, Picasso moves to Madrid to attend the Royal Academy of San Fernando. Frustrated with the school's singular focus on classical subjects and techniques, he begins skipping class to wander the city and paint what he observes.

1900

Picasso visits Paris, selling three canvases to Berthe Weill and meeting his first collector, a Catalan industrialist named Pedro Mañach, who offers him 150 francs a month for his entire output.

THE BLUE PERIOD

La Vie ▶
Pablo Picasso
Oil on canvas, 1903
77 $\frac{5}{16}$ x 50 $\frac{13}{16}$ inches
(197 x 129 cm)

In 1900, Picasso left Spain for Paris with fellow Spanish painter, Carlos Casagemas. The two had met the previous year and had become great friends. By September, Casagemas had fallen in love with a model named Germaine Pichot – known just as Germaine – but the relationship was not without its problems and Germaine eventually rejected him. In a desperate state, Casagemas attempted to shoot Pichot, but missed her. He subsequently committed suicide on 17 February 1901.

This tragedy precipitated Picasso's 'Blue Period', as he poured his grief into a series of melancholy canvases. One of his most poignant works is *La Vie*, in which Picasso substituted his own features for those of his friend Casagemas, his mind clearly haunted by the tragic episode.

SECRETS OF THE PAINTING

- X-rays revealed that underneath the figure of his friend was a self-portrait. It also revealed that it was painted on top of another painting entitled *Last Moments*, inspired by the death of his sister.

- The hand gesture in the centre of the picture is thought to have been copied from Antonio da Correggio's 1525 painting, *Noli me tangere*.

- There are two pictures within the picture. The first, showing an embracing couple, is inspired by the work of Gauguin, while the second, a lone figure, brings to mind Van Gogh.

MALE FIGURE

portrait of Carlos Casagemas

TITLE

translated as

'LIFE'

40 PAINTINGS PAINTED IN THE BLUE PERIOD

1901	1902	1903	1904

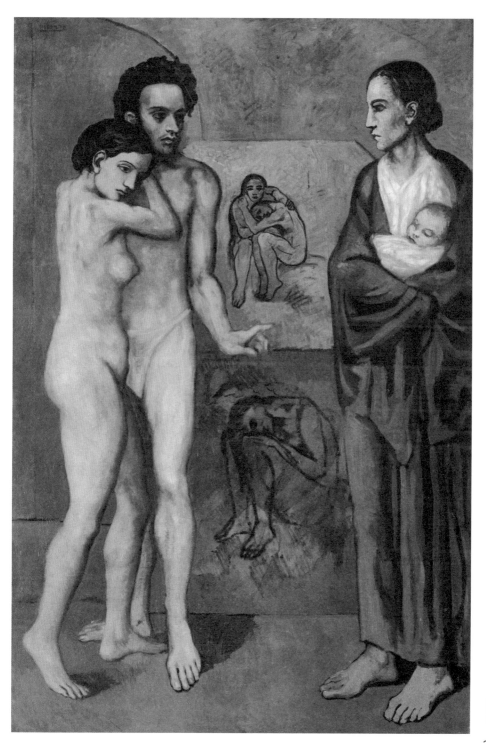

YOUNG ADULTHOOD

1904

In April, Picasso settles in Paris, France, and meets Fernande Olivier (born Amélie Lang), who appears in many of his Rose Period paintings.

1911

French poet Guillaume Apollinaire is arrested on suspicion of stealing the Mona Lisa. He implicates Picasso, but both are released after questioning.

1914

At the start of the First World War, Picasso is living in Avignon, France. Unlike his French associates, Picasso is able to continue painting throughout the war due to his nationality.

1921

Picasso's first child, Paulo, is born on 4 February.

1905

Gertrude Stein becomes Picasso's principal patron, exhibiting his work at her home.

1906

Three days before Picasso's 25th birthday, Paul Cézanne – Picasso's artistic hero – dies in Aix-en-Provence in France.

1908

Picasso and Georges Braque co-found the art movement known as Cubism. Cubism is championed by Daniel-Henry Kahnweiler, one of the leading French art dealers of the 20th century.

1925

Surrealist writer and poet André Breton declares Picasso as "one of ours". Picasso exhibits at the first Surrealist exhibition at the Galerie Pierre in Paris with Man Ray, Jean Arp and Joan Miró.

...AND THAT WAS JUST THE BEGINNING

PAINTER BY NUMBERS

2
WIVES

4
CHILDREN

4
GRANDCHILDREN

8
AGE WHEN HE MADE HIS FIRST PAINTING

13
AGE AT HIS FIRST EXHIBITION

2
NUMBER OF PEACE PRIZES WON

1881

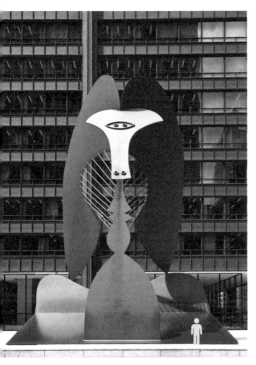

50 feet
(15.24 m)

HEIGHT OF THE SCULPTURE THAT PICASSO DONATED TO THE CITY OF CHICAGO

5 feet 4 inches

PICASSO'S HEIGHT

3 YEARS SPENT AS MUSEUM DIRECTOR AT THE PRADO MUSEUM, MADRID, SPAIN

WORKED
78
YEARS

LIVED
91
YEARS

1973

THE LATER YEARS

1935
Picasso starts writing poetry. On 5 September, his daughter, María de la Concepción (Maya) Picasso, is born.

1936
The Spanish Civil War begins.

1941
Picasso's writes his first play, *Desire Caught by the Tail*.

1937
At the International Exposition of Art and Technology in Modern Life, in Paris, Picasso exhibits the mural-sized canvas, *Guernica*. Later, the painting would be considered the most powerful anti-war statement of modern art.

1944
Picasso joins the French Communist Party. He remains a loyal member until his death.

1947
In May, Picasso's second son, Claude, is born. Picasso begins creating ceramics at the Madoura Pottery in Vallauris in the south of France. He also works on his second play, *The Four Little Girls*.

1951

In January, Picasso completes *Massacre in Korea* (heavily influenced by the work of Goya). The painting is interpreted as a criticism of American intervention in the Korean War.

1962

Picasso is awarded the Lenin Peace Prize.

1973

Picasso dies in Mougins, France.

1949

In April, Picasso's second daughter, Anne Paloma Picasso, is born.

1958

Picasso's sister, Lola, dies.

1967

The 'Chicago Picasso', an untitled 50-foot (15.24-m) sculpture, is unveiled in Chicago. Picasso refuses to be paid $100,000 for it, and instead donates it to the people of the city.

DEATH OF AN ARTIST

PABLO PICASSO
DIED 8 APRIL 1973

Picasso passed away in Mougins, France, at the age of 91, while he and his then wife, Jacqueline Roque, were entertaining friends for dinner. He was buried in the grounds of a château that he had bought on a whim in 1958 in the village of Vauvenargues, near Aix-en-Provence in the south of France. He and Jacqueline had lived there between 1959 and 1961 and it is said that Picasso bought the estate after discovering that it lay on the slopes of Mont Sainte-Victoire, the subject of more than 30 paintings by the Impressionist artist, Paul Cézanne. Picasso's raised burial mound is topped with his 1933 sculpture, *La Femme au Vase*.

"HE DID NOT BLINK. I HAD THE SUDDEN IMPRESSION THAT HE WAS STARING HIS OWN DEATH IN THE FACE, LIKE A GOOD SPANIARD"

—Pierre Daix, on viewing Picasso's
Self-portrait Facing Death, 1972

PABLO PICASSO

02
WORLD

"IT ISN'T UP TO THE PAINTER TO DEFINE THE SYMBOLS. OTHERWISE IT WOULD BE BETTER IF HE WROTE THEM OUT IN SO MANY WORDS. THE PUBLIC WHO LOOK AT THE PICTURE MUST INTERPRET THE SYMBOLS AS THEY UNDERSTAND THEM."

—Pablo Picasso, quoted in *Reading Lezama's Paradiso* by William Rowlandson, 2007

GEOGRAPHIC
MÁLAGA ➡ MOUGINS

1891
The family moves to La Coruña and Picasso is taught at the Escuela de Bellas Artes.

1895
The family relocates to Barcelona, where Picasso attends La Lonja, the city's school of fine arts.

LA CORUÑA

BARCELONA

MADRID

1897
Picasso moves to Madrid to attend the Royal Academy of San Fernando.

MÁLAGA

1881
Picasso is born in Málaga, a city and province with a strong Arab/Moorish influence.

Picasso enjoyed a fairly nomadic lifestyle, settling and resettling throughout Spain and France during the course of his life. He gravitated towards the South of France during the First World War and made this his home until his death in 1973.

1900
Picasso first visits Paris (he would settle there in 1904).

1914
At the start of the First World War, Picasso is living in Avignon, France.

1946
After the Second World War, Picasso settles in Antibes...
...before moving a few kilometres west to Vallauris.

1955
Picasso buys La Californie, a belle-époque villa situated in the foothills of Cannes.

1958
Picasso buys Château de Vauvenargues in the foothills of Mont Sainte-Victoire. Château de Vauvenargues would also become Picasso's final resting place.

1973
Picasso dies in his villa, Notre-Dame-de-Vie, in Mougins, France.

PARIS

VALLAURIS

ANTIBES

AVIGNON

VAUVENARGUES

CANNES

MOUGINS

PICASSO IN PRINT

Picasso was only 19 when he moved to Madrid. Together with his friend, Francisco de Assis Soler, Picasso established *Arte Joven*, a journal in which the artistic and literary developments that had taken place at the turn of the century (and were still occurring), were discussed in a thoroughly 'modern' and revolutionary way. As Art Editor, Picasso provided a huge number of illustrations and the writing was supplied by members of the Spanish literary group, the Generation of 1898. It was a fairly short-lived literary collaboration, but it allowed Picasso to formulate his artistic identity – that of a Modernist.

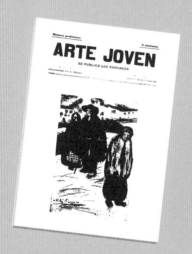

NUMBER OF ISSUES: 5

ARTE JOVEN

FIRST ISSUE:
10 March 1901

LAST ISSUE:
June 1901

LITERARY EDITOR:
Francisco de Asis Soler

ART EDITOR:
Pablo Picasso

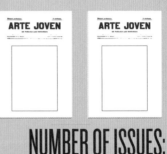

"ARTE JOVEN WILL BE A JOURNAL THAT IS SINCERE."

—*Arte Joven*, 10 March 1901

PÈL & PLOMA

FIRST ISSUE:
3 June 1899

LAST ISSUE:
1 December 1903

LITERARY EDITOR:
Ramon Casas

ART EDITOR:
Miquel Utrillo

NUMBER OF ISSUES:
100

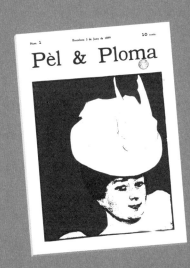

Pèl and Ploma was a Catalan artistic and literary journal produced in Barcelona between 1899 and 1903 by artists Ramon Casas and Miquel Utrillo to extol the virtues of Catalan Modernism. The journal very much informed Picasso's approach to *Arte Joven* and also impacted on his career as a result of Utrillo's profile of Picasso in the magazine. It was the first in-depth article to be written about Picasso's life and work, and the exposure helped propel his name and obvious talent into the psyche of the artistic and literary communities.

27 RUE DE FLEURUS

Writer, art collector and muse, Gertrude Stein, was one of the first Americans in Paris to respond positively to the Modernist revolution of the 20th century. Gertrude and her brother Leo were Picasso's first serious patrons and, together with her life partner, Alice B Toklas, they championed the work of many other emerging artists. They became leading figures in the Parisian avant-garde world of the Left Bank. The Steins' weekly salons, held on Saturday evenings at their home at 27 rue de Fleurus, brought together the prominent names in literature and art at the time, and provided a perfect forum in which to celebrate and critique. Picasso respected Gertrude, and her friendship and patronage proved critical to his growing success.

Mildred Aldrich (1853–1928)

Thornton Wilder (1897–1975)

Henri Matisse (1869–1954)

Henri Rousseau (1844–1910)

Francis Cyril Rose (1909–79)

Ezra Pound (1885–1972)

James Joyce (1882–1941)

Pablo Picasso

artist

writer

poet

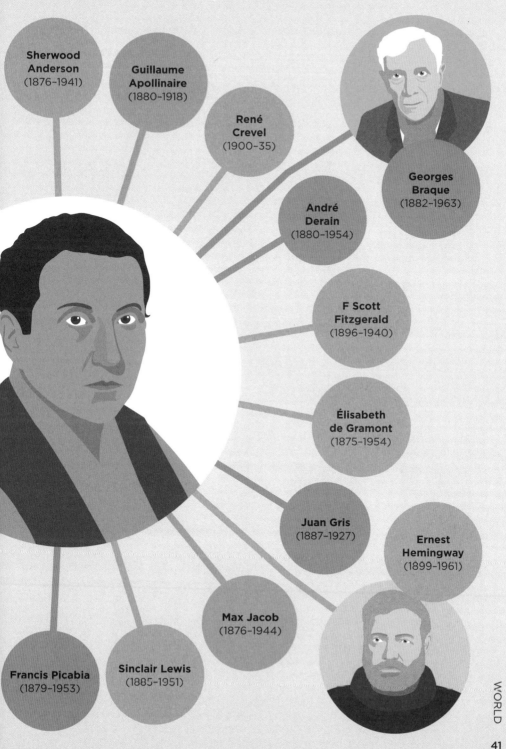

Sherwood Anderson (1876–1941)

Guillaume Apollinaire (1880–1918)

René Crevel (1900–35)

Georges Braque (1882–1963)

André Derain (1880–1954)

F Scott Fitzgerald (1896–1940)

Élisabeth de Gramont (1875–1954)

Juan Gris (1887–1927)

Ernest Hemingway (1899–1961)

Max Jacob (1876–1944)

Francis Picabia (1879–1953)

Sinclair Lewis (1885–1951)

Les Deux Magots

Located in the Saint-Germain-des-Prés area of Paris, Les Deux Magots is one of the oldest cafés in Paris. From the late 19th century, it became renowned as a haunt for the city's resident and transient creatives, attracting a wide range of writers, artists and intellectuals.

The café is named after the two Chinese figures ('deux magots') that adorn it.

FAMOUS PATRONS INCLUDE:

ALBERT CAMUS
ERNEST HEMINGWAY
JAMES JOYCE
ARTHUR RIMBAUD
JEAN-PAUL SARTRE
PAUL-MARIE VERLAINE

In 1935, Picasso was introduced to Dora Maar in the café – she was a gifted artist, poet and photographer closely involved with the Surrealists. It is said that Maar attracted the artist's attention by stretching her hand onto the table and stabbing a knife between her fingers until she drew blood. It is claimed that Picasso kept the bloodstained gloves she wore that day as a memento of their first meeting.

RIVER SEINE

QUAI VOLTAIRE

QUAI MALAQUAIS

QUAI DE CONTI

● **NATIONAL SCHOOL OF FINE ARTS**

RUE BONAPARTE

● **GALERIE CLAUDE BERNARD**

RUE MAZARINE

RUE DE SEINE

RUE DAUPHINE

RUE JACOB

● **MUSÉE DELACROIX**

1 Fr.

400,000 FRANCS

The price paid for the near-bankrupt business by Auguste Boulay in 1914.

BOULEVARD SAINT-GERMAIN

RUE DE RENNES

RUE BONAPARTE

RUE DU FOUR

86 YEARS

The number of years the café has awarded the Prix des Deux Magots literary prize.

1st

WORLD

SPANISH CIVIL WAR (1936–39)

The Spanish Civil War became the stimulus for Picasso to include overt political symbolism in his work. Living in France at the time, Picasso was outraged by Nationalist leader General Francisco Franco's uprising against the Spanish Republican government and expressed his sentiments in the 1937 prints, *The Dream and Lie of Franco*. Picasso continued to use his art as a means of voicing his political beliefs, culminating in the *Guernica*, which was painted in 1937 for the Spanish pavilion at the International Exposition in Paris. Picasso also vowed that he would not set foot in Spain again until Franco was not in power. Sadly Picasso died in 1973, while Franco's dictatorship continued until 1975.

CHILDREN EVACUATED:

30,000 – 35,000

VOLUNTEERS:

35,000 – 40,000

from more than 50 countries rushed to join the International Brigades to defend the Republic.

DEATH TOLL:

TOTAL KILLED 365,000

- 110,000 — Republicans killed in combat:
- 90,000 — Nationalists killed in combat:
- 75,000 — Executed by Nationalists:
- 55,000 — Executed by Republicans:
- 25,000 — Killed by malnutrition:
- 10,000 — Killed by bombs:

TERRITORY CONTROL:

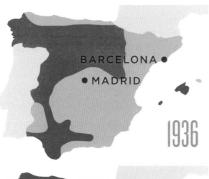

BARCELONA •
• MADRID

1936

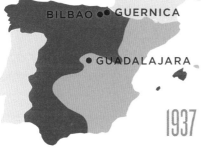

BILBAO • • GUERNICA

• GUADALAJARA

1937

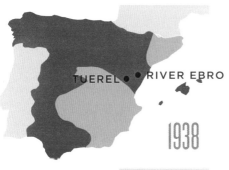

TUEREL • • RIVER EBRO

1938

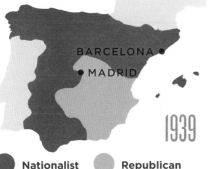

BARCELONA •
• MADRID

1939

● Nationalist ○ Republican

KEY DATES:

1936

February: The Popular Front (republican party) wins the Spanish elections.

July: Military uprisings in Morocco and parts of Spain. Franco declares a "state of war".

October: Franco is named head of state and armed forces.

1937

February: The Nationalists start an offensive against Madrid.

March: The Nationalists are defeated at the Battle of Guadalajara.

April: Guernica is bombed.

June: The Nationalists take Bilbao.

1938

February: The Nationalists are victorious at the Battle of Teruel.

April: The Nationalists take 40 miles of coastline, dividing the Republic in two.

July: The Battle of Ebro begins and will last until November.

1939

January: The Nationalists take Barcelona.

March: The Nationalists occupy Madrid.

April: The Republicans surrender.

THE BOMBING OF GUERNICA (26 APRIL 1937)

The Basque town of Guernica played a pivotal role in the Spanish Civil War. Its destruction would free up northern Spain for the Nationalists and it was for this reason that the aerial bombing of the town occurred. The operation was considered a success by the Nationalists who took Bilbao and subsequently northern Spain. But the attack was extremely contentious as it involved the death of a huge number of civilians (the exact figures are not known). The atrocities and inhumanity of the bombing became the subject matter for Picasso's powerful anti-war painting, *Guernica*.

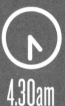

One German plane drops 12 x 110 lb (50 kg) bombs

4.30am

Three Italian planes drop 36 x 110 lb (50 kg) bombs

4.35am

GUERNICA IN NUMBERS

 population

 injured

reportedly killed

actual killed

 5,000

GUERNICA

SPAIN

Three waves of attacks

4.45am – 6.00am

6.30am

29 planes drop remaining bombs

Bombers depart

6.45am

100,000 pounds of high-explosive and incendiary bombs

1,654

889

300

TORO LOCO

Picasso's father was a true aficionado of bullfighting, and he passed his love of the arena on to his son. Picasso attended countless bullfights during his long life and translated his passion for the sport into his art – his bullfight iconography can be seen in his oil paintings, ceramics, lithographs, etchings, engravings and pen and ink, pencil and charcoal drawings.

11

The number of lithographs in the series called *Bull*, created in 1945. Each plate is a successive stage in an investigation to find the absolute spirit of the beast.

8

PICASSO'S AGE WHEN HE COMPLETED HIS FIRST PAINTING, WHICH DEPICTED A MAN RIDING A HORSE IN A BULLFIGHT.

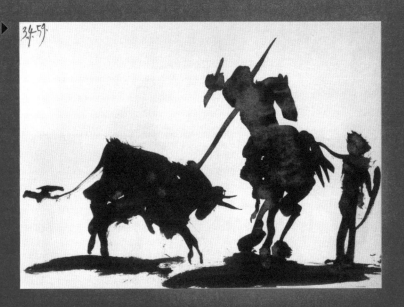

Bullfight Scene ▶
Pablo Picasso
Ink on paper,
1959
18 ⅞ x 24 ½
inches
(48 x 62.3 cm)

14

On 25 February 1960, Picasso made 14 dated, numbered and signed drawings depicting different moments and protagonists of the bullfight. While thirteen of the drawings are ink wash drawings, one (number 13) was made in pastel, India ink and wash. They were first shown at the Galerie Louise Leiris, Paris, at the end of 1960.

● Ink wash ● Pastel & India Ink

5 THINGS YOU MAY NOT KNOW ABOUT PICASSO

1 He considered Inès Sassier – his housekeeper and maid for more than a quarter of a century – his confidante. Picasso painted her portrait for many years as a gift for her birthday.

2 Picasso believed that in the wrong hands his hair trimmings could be used to control him. Consequently, he only had one barber that he trusted throughout his life.

3 Picasso could draw before he could speak. According to his mother, his first word was 'piz', short for *lápiz*, the Spanish word for pencil.

4 In 1949, the Paris World Peace Conference adopted a dove created by Picasso as the official symbol of several peace movements.

5 In 1973, the year of his death, Picasso was honoured through the use of his portrait on stamps worldwide.

PABLO PICASSO

03
WORK

"A PICTURE IS NOT THOUGHT OUT AND SETTLED BEFOREHAND. WHILE IT IS BEING DONE IT CHANGES AS ONES THOUGHTS CHANGE. ...

"... AND WHEN IT IS FINISHED IT STILL GOES ON CHANGING, ACCORDING TO THE STATE OF MIND OF WHOEVER IS LOOKING AT IT."

—Pablo Picasso, quoted in *Picasso on Art*
by Dore Ashton, 1972

PERIODS OF WORK

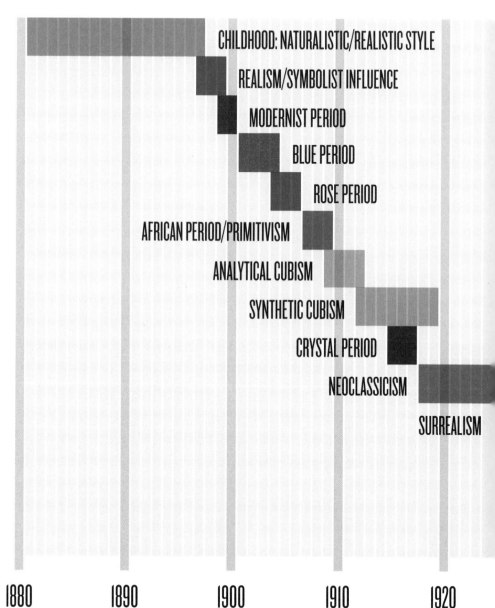

CHILDHOOD: NATURALISTIC/REALISTIC STYLE

REALISM/SYMBOLIST INFLUENCE

MODERNIST PERIOD

BLUE PERIOD

ROSE PERIOD

AFRICAN PERIOD/PRIMITIVISM

ANALYTICAL CUBISM

SYNTHETIC CUBISM

CRYSTAL PERIOD

NEOCLASSICISM

SURREALISM

1880 1890 1900 1910 1920

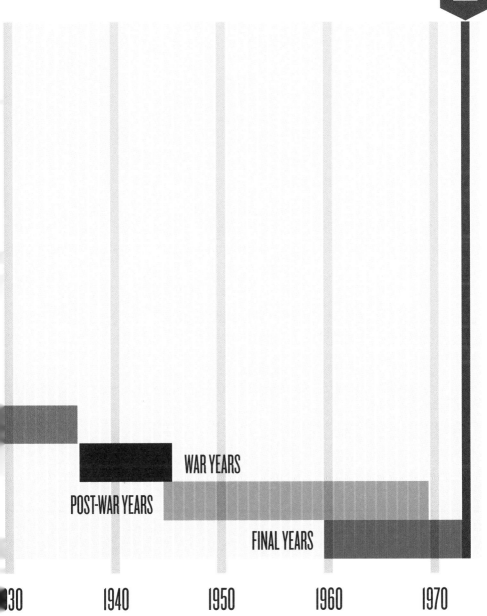

DEATH

WAR YEARS

POST-WAR YEARS

FINAL YEARS

30 1940 1950 1960 1970

BIOGRAPHIC LES DEMOISELLES D'AVIGNON

Picasso began painting *Les Demoiselles D'Avignon* at the start of 1907, but so ahead of its time was the painting that even Picasso did not feel ready to exhibit the work publicly until 1916. It has since become one of the most important paintings of the 20th century.

FIVE FACTS ABOUT LES DEMOISELLES D'AVIGNON

1. **Picasso was influenced by the Iberian sculptures he had seen in the Louvre, Paris, and African artefacts at the Palais du Trocadéro, also in Paris. In the painting, two of the women are depicted with facial features similar to those found on African masks.**

2. **The painting was originally meant to be a narrative brothel scene, depicting two men and five women. However, as Picasso worked on it he decided to paint over the two men and just focus on the five women.**

3. **The content was so shockingly new that the general reaction among Picasso's peers was one of abhorrence. Matisse interpreted it as a hoax, while Gertrude Stein referred to it as "a veritable cataclysm".**

4. **Picasso's original title for the painting was *Le Bordel d'Avignon* (*The Brothel of Avignon*), but art critic André Salmon, who managed the exhibition, thought it was too shocking and encouraged Picasso to change the name.**

5. **In 1924, the painting was sold to French fashion designer Jacques Doucet for 25,000 francs. A few months later, the painting was valued in the region of 250,000–300,000 francs.**

Les Demoiselles D'Avignon ▶
Pablo Picasso
Oil on canvas, 1907
96 x 92 inches (244 x 234 cm)

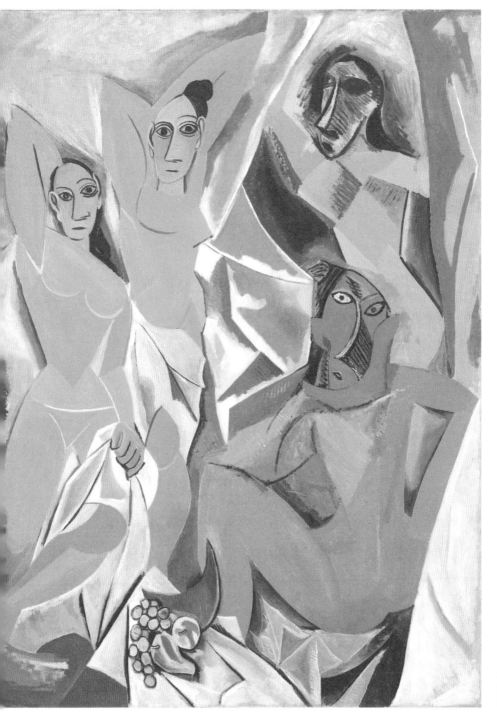

PICASSO'S WORKING DAY

People who achieve greatness are known to have extremely disciplined daily routines. Picasso went to bed late and got up late; a classic night owl. When he was not working he was thinking about work. Picasso was rarely bored by painting and could spend several hours in front of a canvas without feeling tired.

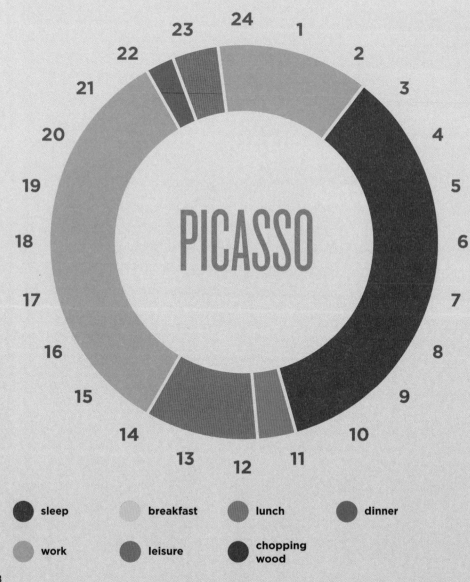

sleep breakfast lunch dinner

work leisure chopping wood

2 wives

Most expensive painting:

$179.4m

|||||||||||||||||||||||||||

for *Les Femmes d'Alger (Version O)* – painted as a tribute to Matisse

PICASSO

From the south of Spain

Founded Cubism with one-time Fauvist, Georges Braque

4 children; 3 born out of wedlock

Inclined to work from imagination

WORKING LIFE: 78 YEARS

LIVED: 1881 – 1973

Died of a heart attack, aged 91

MATISSE

Most expensive painting:

$33.6m

for L'Odalisque, Harmonie Bleue

Between them, these giants of modern art introduced many of the most significant developments of 20th-century painting and sculpture. The epitome of 'frenemies', Matisse once referred to their relationship as a boxing match. However, despite their initial rivalry, each artist came to acknowledge the other as his only true equal, with each possessing the power to challenge and stimulate creativity within the other.

From the north of France

wife

Leader of the Fauvist movement with André Derain; rejected Cubism

3 children; 1 born out of wedlock

LIVED: 1869 – 1954 Died of heart failure, aged 84

WORKING LIFE: 50+ YEARS Started painting in 1889, having trained as a lawyer

Drew and painted from nature

BIOGRAPHIC GUERNICA

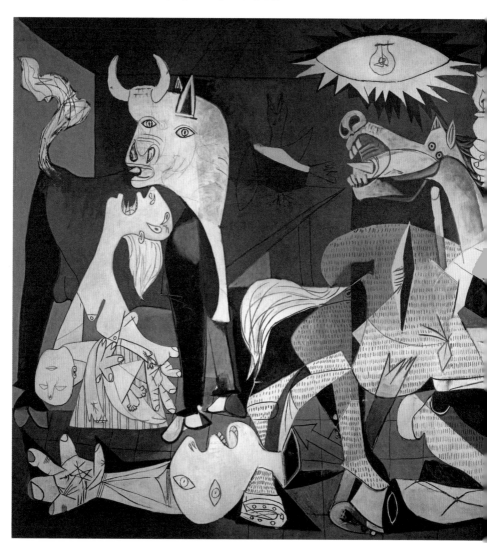

Guernica is undoubtedly Picasso's most powerful political statement, expressing universal horror and indignation at the destruction of the Basque village of Guernica in northern Spain. The tragedy was the result of bombing by German and Italian war planes at the request of General Francisco Franco and Spanish Nationalists. The Spanish Republican government commissioned the painting to display at the International Exposition of Art and Technology in Modern Life at the 1937 World's Fair in Paris.

▼ *Guernica*
Pablo Picasso
Oil on canvas, 1937
25 x 12 feet (7.76 x 3.49 m)

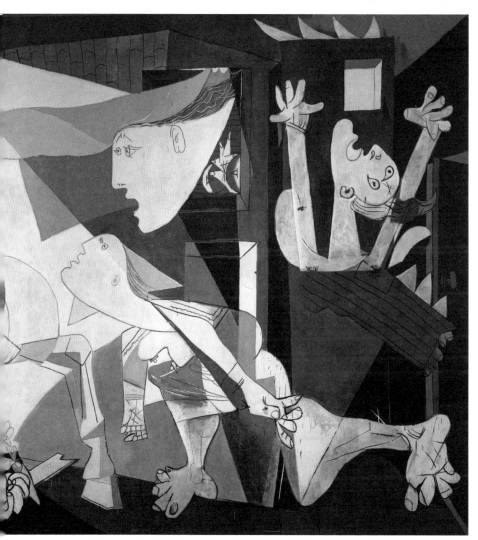

THEMES

- The horse, falling down in agony, represents the people of Guernica.
- The rampaging bull is a motif of destruction, used to represent the onslaught of Fascism.

COMPOSITION

- Picasso's palette is reduced to funereal greys, blacks and whites, which produce a reportage-like quality.

1899–1900
Modernist Period

1901–1904
Blue Period

1925–1936
Surrealism

1918–1925
Neoclassicism

1937–1945
The War Years

1945–1960s
Post War

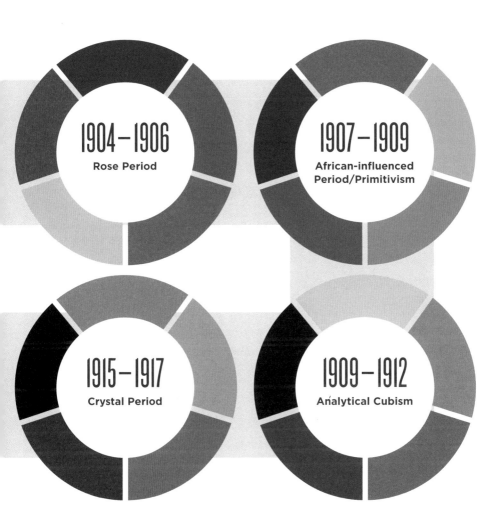

CHANGING PALETTES

Colour was of immense importance to Picasso, and the artist is known for several distinct colour phases throughout his career. However, during his later years he almost abandoned colour altogether, executing his paintings in ochres, greys, creams and browns.

10 THINGS YOU MAY NOT KNOW ABOUT PICASSO'S WORK

1 As well as sprinkling powdered pigment directly on the canvas and mixing paint with materials such as sand and newspaper to vary the texture, Picasso used industrial paints alongside the more traditional oil brands; he particularly liked a type of enamel paint made by a firm called Ripolin.

2 Using a nanoprobe, physicists at Argonne National Laboratory, Illinois, USA, confirmed in 2012 that Picasso used common household paint in many of his paintings – *The Red Armchair* is one such example.

3 According to his biographer, John Richardson, Picasso would often repay people's hospitality by giving them one of his artworks. However, in later life he gave people caviar instead, joking that the prices for his art had risen so high that caviar was cheaper.

· CAVIAR ·

4 In 1997, the billionaire casino mogul, Steve Wynn, purchased Picasso's *Le Reve* for $48m. In 2006, Wynn agreed to sell the painting to hedge fund manager and art collector, Steve Cohen, but at a celebratory get-together, Wynn accidentally put his elbow through the painting. The sale was postponed so that the damage could be repaired, and the painting was eventually sold to Cohen in 2013 at a price of $155m – $16m more than it would have sold for in 2006.

5 Much of Picasso's painting was done at night, under artificial lights.

6 Picasso did not rely on commissions and only sold a portion of his work, keeping hold of most of his sculptures, paintings and drawings. Upon his death, a large number of these works were given to museums around the world and over 10,000 separate artworks were passed on to his granddaughter, Marina.

7 On 18 April 2016, ten of Picasso's kidney-shaped palettes went on show in Madrid.

8 Never much of a letter writer, Picasso substituted drawing for writing and sent vivid sketches to his parents and friends, depicting what he'd been up to.

9 At the time of his death in 1973, Picasso was the world's wealthiest artist, leaving an estate valued somewhere between $100 million and $260 million.

10 Picasso died without leaving a will. As part of an agreement with his family and the state, a number of works of art were donated to the French government in lieu of inheritance tax. These formed the basis of the Picasso Museum in Paris.

BIOGRAPHIC WEEPING WOMAN

Painted in 1937, Picasso's *Weeping Woman* represents a thematic continuation of the distressed female seen in *Guernica*, and the last in a whole series on the subject. For Picasso, the grieving woman symbolized the anguish and devastation caused by the Spanish Civil War. The model – as in *Guernica* – was Picasso's muse at the time, Dora Maar. On choosing Maar, Picasso explained, "For me she's the weeping woman. For years I've painted her in tortured forms, not through sadism, and not with pleasure, either; just obeying a vision that forced itself on me. It was the deep reality, not the superficial one … Dora, for me, was always a weeping woman … And it's important, because women are suffering machines."

PALETTE

Picasso frequently used a monochrome palette when evoking pain and suffering. By contrast, the palette used in *Weeping Woman* is bold and bright. Her tears wash away the colour to expose a cold, white layer below.

COMPOSITION

It is painted in the flattened style of Picasso's early analytical Cubism, characterized by the use of angular and overlapping fragments of the subject's face. It almost seems as if it were painted from different viewpoints simultaneously.

SIZE

■ *Weeping Woman*
19 x 24 inches (50 x 61 cm)

■ *Guernica*
25 x 12 feet (7.76 x 3.49 m)

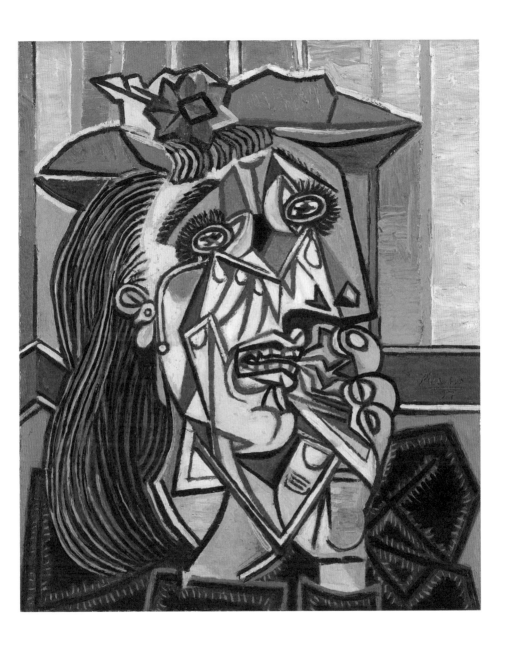

▲ *Weeping Woman*
Pablo Picasso
Oil on canvas, 1937
19 x 24 inches (50 x 61 cm)

THEMES

🐂 Minotaur

⬛ Sculptor's studio

▦ Other

⬛ Rembrandt

⬛ Ambroise Vollard

Between 1930 and 1937 Picasso produced the *Vollard Suite* – a series of 100 etchings commissioned by Ambroise Vollard. The main subject of the series was Picasso's own studio in which he often depicted himself as a sculptor and his young lover, Marie-Thérèse Walter, as a model. The Minotaur – the half-man, half-bull of classical mythology – featured in a number of the works and Picasso also tilted his cap to Rembrandt in a group of etchings, concluding the series with portraits of Vollard himself.

PICASSO AND THE MINOTAUR

In 1942, Picasso created the *Tete de Taureau* or *Bull's Head,* drawing inspiration from his childhood memories of bullfighting and the Greek myth of the Minotaur. The sculpture epitomizes Picasso's originality and sense of playfulness. However, when it was exhibited in Paris in 1944, it was so badly received that there was a public outcry, forcing the gallery owners to remove it from the wall. Over time, the beautifully simple representation of the bull has led to it being recognized as a masterpiece, with British artist Roland Penrose describing it as an "astonishingly complete" metamorphosis. The artwork now resides in the permanent collection of the Picasso Museum in Paris.

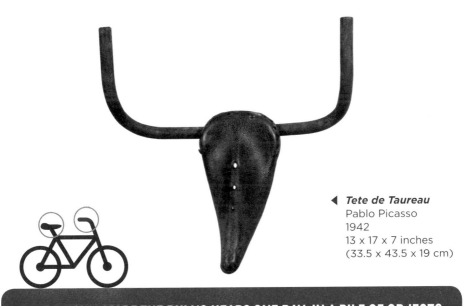

◀ **Tete de Taureau**
Pablo Picasso
1942
13 x 17 x 7 inches
(33.5 x 43.5 x 19 cm)

"GUESS HOW I MADE THE BULL'S HEAD? ONE DAY, IN A PILE OF OBJECTS ALL JUMBLED UP TOGETHER, I FOUND AN OLD BICYCLE SEAT RIGHT NEXT TO A RUSTY SET OF HANDLEBARS. IN A FLASH, THEY JOINED TOGETHER IN MY HEAD. THE IDEA OF THE BULL'S HEAD CAME TO ME BEFORE I HAD A CHANCE TO THINK. ALL I DID WAS WELD THEM TOGETHER."

—**Pablo Picasso, quoted in *Conversations with Picasso* by George Brassai, 1964**

LAS MENINAS

In the 1950s, Picasso's style changed once again, as he took to producing reinterpretations of the art of the great masters, including Courbet, Delacroix, Goya, Manet, Poussin and Velázquez.

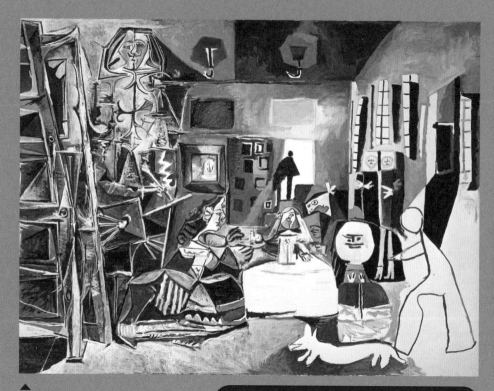

▲
Las Meninas
Pablo Picasso
Oil on canvas, 1957
76 x 102 inches (194 x 260 cm)

"IF I WERE TO SET MYSELF TO COPYING IT, THERE WOULD COME A MOMENT WHEN I WOULD SAY TO MYSELF: NOW WHAT WOULD HAPPEN IF I PUT THAT FIGURE A LITTLE MORE TO THE RIGHT OR A LITTLE MORE TO THE LEFT? ... SO LITTLE BY LITTLE I WOULD PROCEED TO MAKE A PICTURE, LAS MENINAS, WHICH FOR ANY PAINTER WHO SPECIALIZED IN COPYING WOULD BE NO GOOD; IT WOULDN'T BE THE MENINAS AS THEY APPEAR TO HIM IN VELÁZQUEZ'S CANVAS, IT WOULD BE MY MENINAS."

—Pablo Picasso, quoted in *Picasso: The Artist of the Century* by Jean Leymarie, 1971

Las Meninas ▶
Diego Velázquez
Oil on canvas, 1656
126 x 111 inches
(321 x 282 cm)

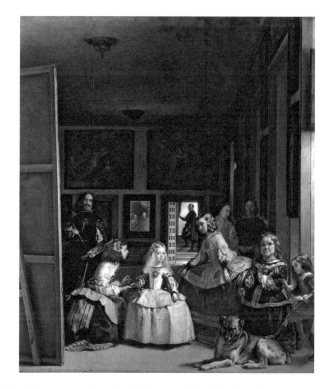

58

The number of times in 1957 that Picasso painted variations on *Las Meninas* by Diego Velázquez. The series of paintings consists of 45 interpretations of the original picture, nine depictions of a dove, three landscapes and a portrait of Jacqueline Roque. The 58 individual works are housed at the Museu Picasso in Barcelona and is the only complete series of the artist that remains together.

● Interpretations of the original picture ● Doves ● Landscapes ● Portrait of Jacqueline Roque

PICASSO THE WRITER

Picasso's talents knew no bounds. Besides his prolific output of paintings he was also an accomplished sculptor, printmaker, ceramicist and stage designer. However, few people think of Picasso as a poet and playwright, yet writing was extremely important to him throughout his whole life. In 1935, Picasso took up the craft of writing seriously and up until 1959 he would write almost every day. Picasso initially kept his writing a secret, but as he grew in confidence and formulated his own style he began to share poems in letters to his friends. He was fortunate to receive a great deal of nurturing from the Surrealist poets Michel Leiris and André Breton.

Picasso wrote

300+

poems

2 plays:

Desire Caught by the Tail and *The Four Little Girls*

Book of poetry:

The Burial of the Count of Orgaz or *El Entierro del Conde de Orgaz.*

Created January 1957 to August 1959

Published in 1969

263 COPIES

PABLO PICASSO

04
LEGACY

"PICASSO FULLY JUSTIFIES THE SAYING WHICH HAS IT THAT MAN AND THE WORLD ARE DAILY CREATED BY MAN."

—Albert Einstein, quoted in *Picasso: The Artist of the Century* by Jean Leymarie, 1972

IT'S A STEAL!

The Art Loss Register – an organization that helps track and recover stolen art around the world – ranks Picasso as the current most stolen artist in the world. In recent years a total of 1,147 of his artworks have gone missing and it appears that the United Kingdom is the hotbed of crime with 40 per cent of art thefts happening there, compared with only 16 per cent in the United States. The fact that the number of stolen paintings by Picasso is more than double Nick Lawrence's – who is ranked at number two on the list – is attributed to the fact that Picasso's oeuvre is incredibly valuable and his output was vast, having lived to the ripe old age of 92, with a career that spanned nearly 80 years.

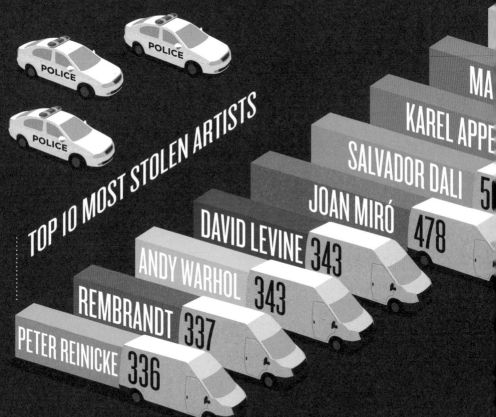

TOP 10 MOST STOLEN ARTISTS

MA

KAREL APPE

SALVADOR DALI 5

JOAN MIRÓ 478

DAVID LEVINE 343

ANDY WARHOL 343

REMBRANDT 337

PETER REINICKE 336

CK LAWRENCE **557**

AGALL **516**

05

PABLO PICASSO **1,147**

Le pigeon aux petits pois ▶
Pablo Picasso
Oil on canvas, 1911
21 x 26 inches
(53 x 66 cm)

**Stolen from the
Musée d'Art Moderne
de la Ville de Paris
in May 2010**

ESTIMATED VALUE:

€100m (with four
other stolen
pieces)

CUBISM

Cubism is considered by many to be one of the most influential art movements of the 20th century. In 1907, the French poet, Guillaume Apollinaire, introduced Picasso to the artist Georges Braque. They shared a deep fascination with the work of Cézanne and through a continued study of his work they jointly pioneered what would become known as Cubism. The Cubist way of seeing does not distinguish between foreground and background, shapes are simplified into blocks, scale and perspective are of no importance, and angles are all seen at once.

ANALYTICAL CUBISM

The Cubist movement can be divided into two fairly separate periods. The first was Analytical Cubism (1909–1912), which involved analyzing various objects in terms of their shapes. The palette popular at this time was a fairly monochrome one, favouring browns and neutral colours.

SYNTHETIC CUBISM

The second period was known as Synthetic Cubism (1912–1919), which involved creating collaged works of art from cut paper, usually newspapers and wallpapers. This approach to mark making was the first use of collage in fine art.

CUBISM'S CONNECTION TO OTHER ART MOVEMENTS

1890 1895 1900

POST-IMPRESSIONISM

African sculpture

DIVISION

SYNTHETISM

Japanese prints

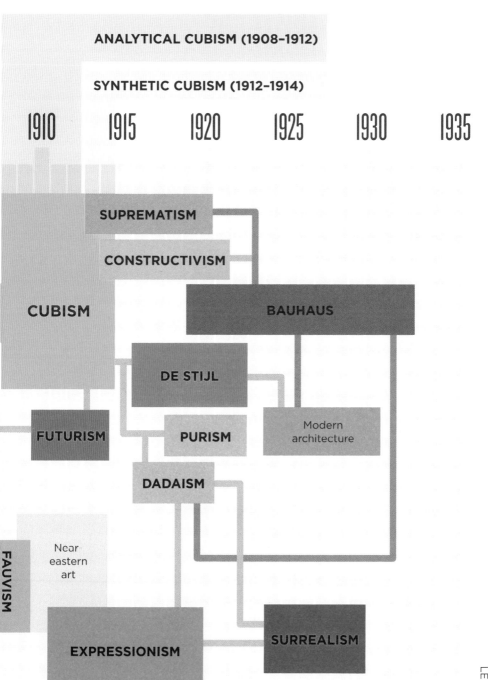

ANALYTICAL CUBISM (1908–1912)

SYNTHETIC CUBISM (1912–1914)

1910 1915 1920 1925 1930 1935

SUPREMATISM

CONSTRUCTIVISM

CUBISM

BAUHAUS

DE STIJL

FUTURISM PURISM Modern architecture

DADAISM

Near eastern art

FAUVISM

EXPRESSIONISM SURREALISM

PAINTING BY NUMBERS

During a career that lasted 78 years, Picasso produced more than 150,000 works of art, leading the *Guinness World Records* to recognize him as the world's most prolific painter. By comparison, Paul Cézanne (Picasso's hero) produced fewer than 1,000 oil paintings and 500 watercolours – including many incomplete works – during his 40-year career.

150,000+ TOTAL WORKS OF ART

= 1,000

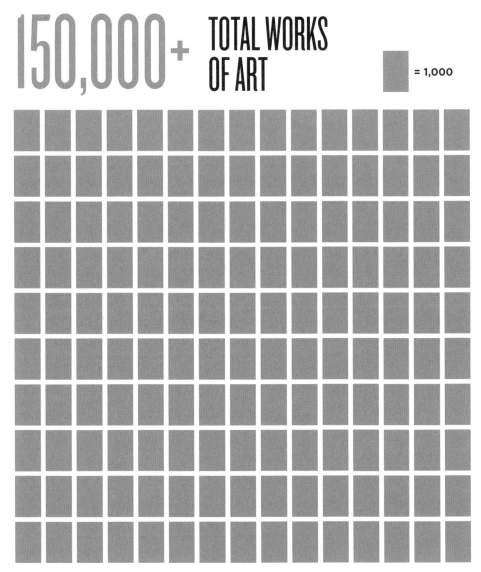

300 SCULPTURES

13,500 PAINTINGS

2,880 CERAMICS

34,000 ILLUSTRATIONS

100,000 PRINTS

WHERE TO SEE A PICASSO

Picasso's works are held in major galleries around the world, so no matter where you are on the planet there is a strong chance there is a Picasso nearby. There is also a number of museums dedicated purely to the artist, which is a great way of exploring his art in its many and varied forms. However, at the same time, some key paintings rest in the hands of private collectors, where they sit out of sight of the public's eyes.

TOP 5 COLLECTIONS AROUND THE WORLD

- FRANCE
- SPAIN
- GERMANY

01

MUSÉE NATIONAL PICASSO, PARIS

OPENED:	TOTAL WORKS:
1985	5,000+

02

MUSEU PICASSO, BARCELONA

Founded on a donation of 574 works by Picasso's secretary, Jaime Sabartés.

OPENED:	TOTAL WORKS:
1963	3,000+

03

MUSEUM LUDWIG, COLOGNE

OPENED:	TOTAL WORKS:
1976	**888**

04

MUSEO PICASSO, MÁLAGA

OPENED:	TOTAL WORKS:
2003	**233**

05

MUSÉE PICASSO, ANTIBES

Château Grimaldi in Antibes became the Musée Picasso in 1966.

TOTAL WORKS:

245

TYPOGRAPHIC PICASSO

Old, grotesque dwarfs

Magical

Bull

Blue Period

The Dream

Minotaur

The Old Guitarist

Cultural hero

Guitar

Legend

Ceramicist

Seated Woman

Nude

Don Juan

Horses

Sculptor

Harlequins / saltimbanque

Distorted women

Reinvention

Cubism

The Weeping Woman

Etchings

Boy Leading a Horse

Acrobats

The destroyer

Prolific

Guernica

Creator

Maya with her Doll

Primitivism

Breton striped

Seducer

Artist

ICONIC BRETON SHIRT

In 1858, a decree from the French Navy officially listed the *tricot rayé* (striped knit) shirt as part of the new uniform for the seamen of Brittany. The order instructed that the body of the shirt must have 21 white stripes, with each one twice as wide as the blue stripes. The continuous stripe from shirt to sleeve was to allow for easier spotting of sailors in the distance. The Breton shirt has since become an important fashion item, with Picasso famously seen in a variety of versions of the striped shirt.

THE 21 HORIZONTAL STRIPES ARE SAID TO REPRESENT EACH OF NAPOLEON'S VICTORIES OVER THE BRITISH.

◀ **Coco Chanel** brought the Breton shirt to the world of fashion in 1917, and it is still very much en vogue.

PICASSO AT AUCTION

Picasso is one of the defining artists of the 20th century. Few artists have achieved the same level of success and notoriety as he did and few have been as influential as him in shaping the work of future generations of artists as well as the general public's understanding of what art is. It is therefore of little surprise that many of Picasso's works rank among the most expensive paintings in the entire world.

In 2004, *Garcon a la pipe* sold at Sotheby's for a whopping US$104 million, establishing a new price record at the time. 2006 saw the sale of *Dora Maar au Chat* for $95.2 million, in 2010 *Nude, Green Leaves and Bust* sold at Christie's for $106.5 million, and in 2016 *Femme Assise* sold for $63.4 million at Sotheby's. However, the highest price ever paid for a painting is for *Les Femmes d'Alger (Version O)*, which sold for an incredible $179,365,000 at Christie's in New York in 2015.

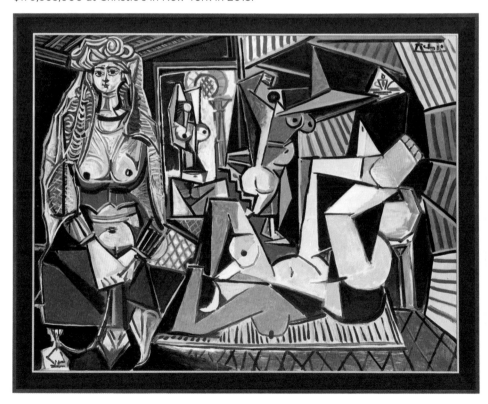

▲
Les Femmes d'Alger (Version O)
Pablo Picasso
Oil on canvas, 1955
44 7/8 x 57 5/8 inches
(114 x 146.4 cm)

WHAT YOU CAN BUY FOR THE PRICE OF ONE PICASSO PAINTING:

$493,000 to spend each day, every day, for 1 year

2,740 years living on a cruise ship

60 of the world's most expensive supercars

360 trips to Mars with S P A C E X

180,000 Apple iPhones

3,800,000 bottles of absinthe

7,200,000 fine Cuban cigars

3,600,000 Breton shirts

180,000,000 slices of pizza

BIOGRAPHIES

Gertrude Stein (1874–1946)
The American writer moved to Paris in 1903. Her weekly salons attracted leading figures of literature and art. Stein championed emerging artists, but was initially hesitant about Picasso's work. Eventually her patronage and friendship became critical to Picasso's success.

Carlos Casagemas (1881–1901)
An artist and poet, Casagemas first met Picasso in Barcelona and they bonded over their mutual love of art. The two became great friends and Picasso was left devastated by Casagemas's suicide at the tragically young age of 20.

Paul Cézanne (1839–1906)
Referred to by Picasso as his artistic 'father', Cézanne's Post-Impressionist work is considered the bridge between Impressionism and early modern art movements such as Cubism.

Dora Maar (1907–97)
French photographer, painter and poet, Maar was Picasso's lover and muse in the late-1930s and early-1940s. She is most recognized as the face of *Weeping Woman*.

Olga Khokhlova (1891–1955)
A Russian ballet dancer, Khokhlova was Picasso's first wife and mother of his first son, Paulo. The pair married in 1918, but split in 1935. The couple never divorced and were still married at the time of her death at the age of 63.

Jaime Sabartés (1881–1968)
Sabartés was a Spanish artist, poet and writer who became a close friend of Picasso. In 1935, he became Picasso's secretary and helped to arrange his exhibitions.

Juan Gris
(1887–1927)
Close friend and artistic associate of Picasso's. Gris was also an advocate of the Cubist movement.

Jacqueline Roque
(1927–86)
Picasso's second wife, Jacqueline Roque, was married to the artist from 1961 until his death in 1973. Unable to recover from the loss of her husband, Roque committed suicide 13 years later.

Françoise Gilot
(1921–)
Gilot is a French painter, critic and writer. She was in a relationship with Picasso from 1943 to 1953 and is the mother of his two youngest children, Claude and Paloma.

Henri Matisse
(1869–1954)
Picasso's main artistic sparring partner, Matisse became a life-long friend and rival. Both artists bounced off one another from the first time Picasso saw Matisse's *Woman with a Hat* (1905) at the home of Gertrude Stein.

Jean Cocteau
(1889–1963)
Writer, designer, playwright, artist, filmmaker and close associate of Picasso. Cocteau's final film, *Le Testament d'Orphée* (*The Testament of Orpheus*) (1960), featured a cameo by Picasso.

Diego Velázquez
(1599-1660)
One of the most important painters of the Spanish Golden Age, Velázquez's artwork has influenced artists ever since. In 1957, Picasso painted 58 variations on Velázquez's *Las Meninas*.

- friend
- artist
- lover

INDEX

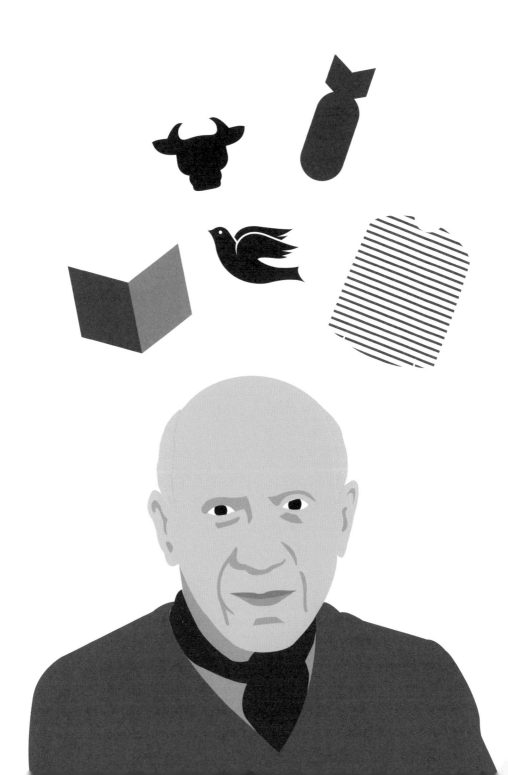